DOVER MASTERWORKS

Color Your Own

VAN GOGH

Paintings

Rendered by
Marty Noble

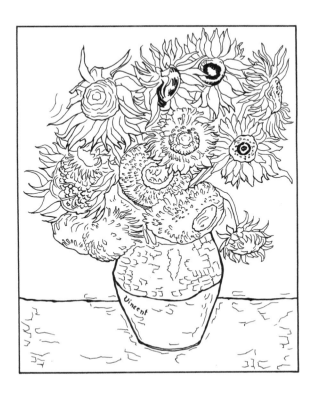

Dover Publications, Inc.
Mineola, New York

Note

Expressive brushwork, the heightened use of color, and an intense emotionality exemplify the style of Vincent van Gogh (1853–1890). The oldest child of a pastor, the Dutch Post-Impressionist tried such varied careers as language teacher, art dealer, and preacher before he began to paint in earnest in 1880. During the first four years of his artistic career, he specialized in drawings and watercolors. From 1884 until his premature death, the destitute van Gogh focused his talents on oil painting.

Inspired by Impressionism, Japanese prints, and French painting, van Gogh soon developed a unique style. He attempted to organize a working artists' community in Arles with Toulouse-Lautrec and Gauguin, but a quarrel with Gauguin in 1888 provoked van Gogh into cutting off part of his own ear. Plagued throughout his life with mental difficulties, van Gogh was admitted to an asylum at his own request.

Van Gogh's artistic career was brief, lasting merely one decade. Distraught and riddled with despair, he took his own life in 1890. Sadly, it was only after his death that attention was drawn to his work. Although he produced 800 oil paintings and 700 drawings, he only sold a single painting during his lifetime.

Rendered by artist Marty Noble, the thirty van Gogh paintings in this book will appeal to coloring enthusiasts as well as anyone interested in fine art. All of the paintings are shown in full color on the inside covers for easy reference. Choose your media, and then follow van Gogh's color scheme for an accurate representation of the original work, or pick your own colors for a more personal touch. When you're finished coloring, the perforated pages make it easy to display your finished work. Captions on the reverse side of each plate identify the title of the work, date of composition, medium employed, the size of the original painting, and include interesting facts about the piece.

Copyright

Copyright © 1999, 2013 by Dover Publications, Inc.
All rights reserved.

Bibliographical Note

Dover Masterworks: Color Your Own Van Gogh Paintings, first published by Dover Publications, Inc., in 2013, is a slightly altered republication of *Color Your Own Van Gogh Paintings*, first published by Dover in 1999.

International Standard Book Number

ISBN-13: 978-0-486-77950-8
ISBN-10: 0-486-77950-5

Manufactured in the United States by RR Donnelley
77950509 2015
www.doverpublications.com

Guide to the Van Gogh Paintings

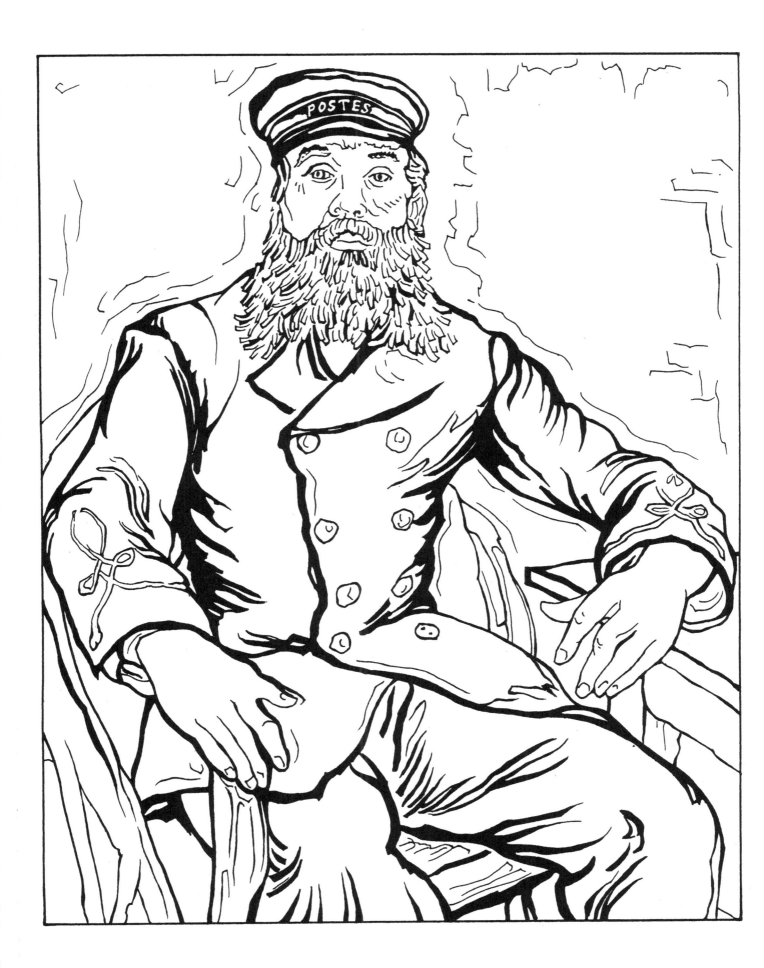

Plate 1
***Portrait of the Postman Joseph Roulin*, 1889**
Oil on canvas. 31¾ x 25¾ in.

Portrait of the Postman Joseph Roulin was completed as part of a group of portraits that van Gogh made of the Roulin family during the winter of 1888, painting each member of the family, including all three of the children, multiple times. Joseph Roulin and his wife Augustine were some of the only friends van Gogh had during the two years he spent living in Arles.

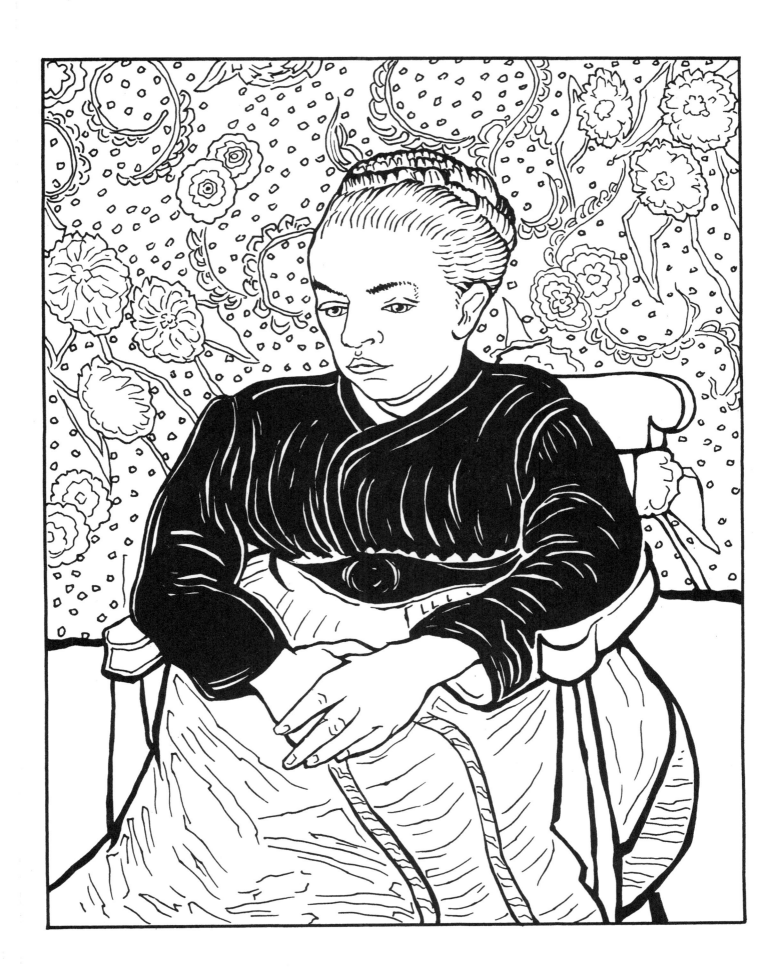

Plate 2
La Berceuse (Augustine Roulin), 1889
Oil on canvas. 35¾ x 28 in.

The subject of this painting is Madame Augustine Roulin, one of van Gogh's few friends in Arles. The string she is holding in this portrait is attached to her infant daughter's cradle, which she rocked throughout the sitting. According to van Gogh, *Le Berceuse*, which translates literally as "the lullaby" refers both to the woman rocking the cradle as well as the song she sings.

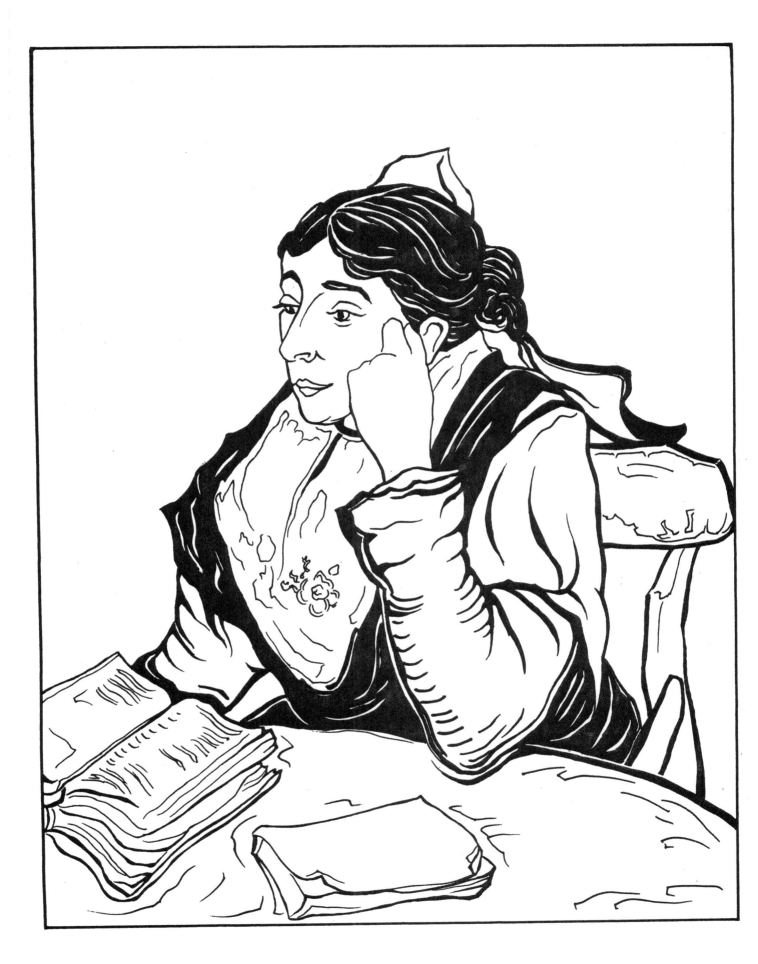

This work is one of six portraits that van Gogh painted of Madame Marie Ginoux, owner of the Café de la Gare in Arles. For four months in 1888, van Gogh lodged at her café, which also became the subject of *The Night Café.*

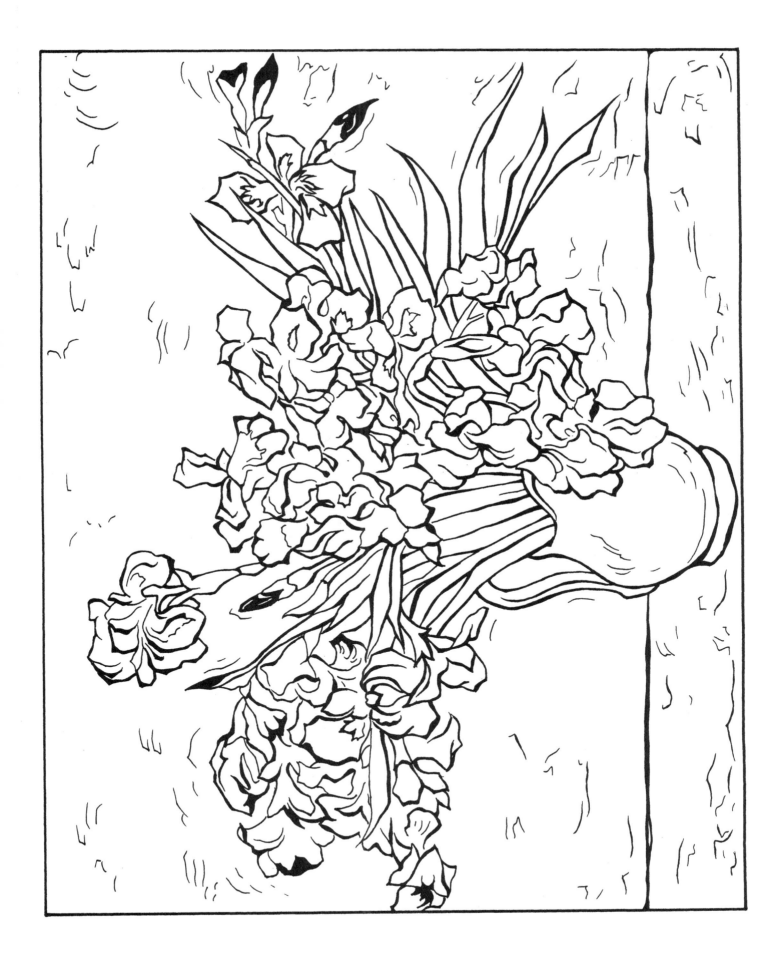

Plate 4
Still Life: Vase with Irises, **1890**
Oil on canvas. 29 x 36¼ in.

This work, one of van Gogh's most well-known still life paintings, was completed at the asylum of Saint-Paul-de-Mausole in Saint-Rémy, Provence, where van Gogh voluntarily admitted himself in 1889.

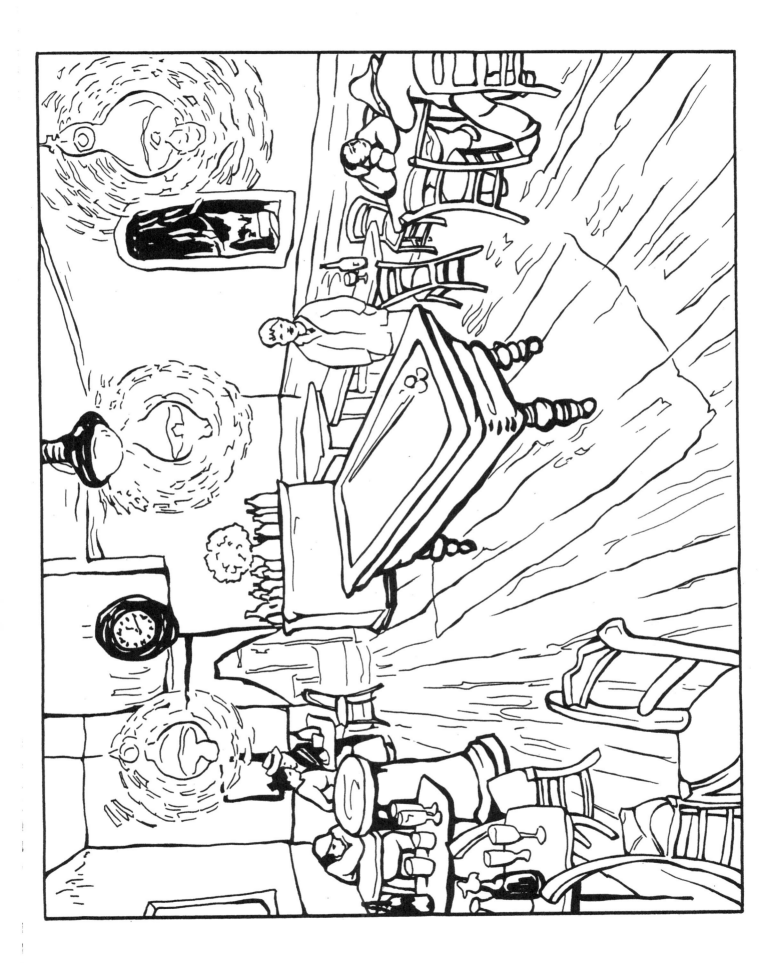

The subject of this painting is the inside of the Café de la Gare. In a letter to his brother Theo, van Gogh wrote the following about this work: "In my picture of the 'Night Café' I have tried to express the idea that the café is a place where one can ruin oneself, go mad, or commit a crime. So I have tried to express, as it were, the powers of darkness in a low public house, by soft Louis XV green and malachite, contrasting with yellow-green and harsh blue-greens, and all this in an atmosphere like a devil's furnace, of pale sulphur."

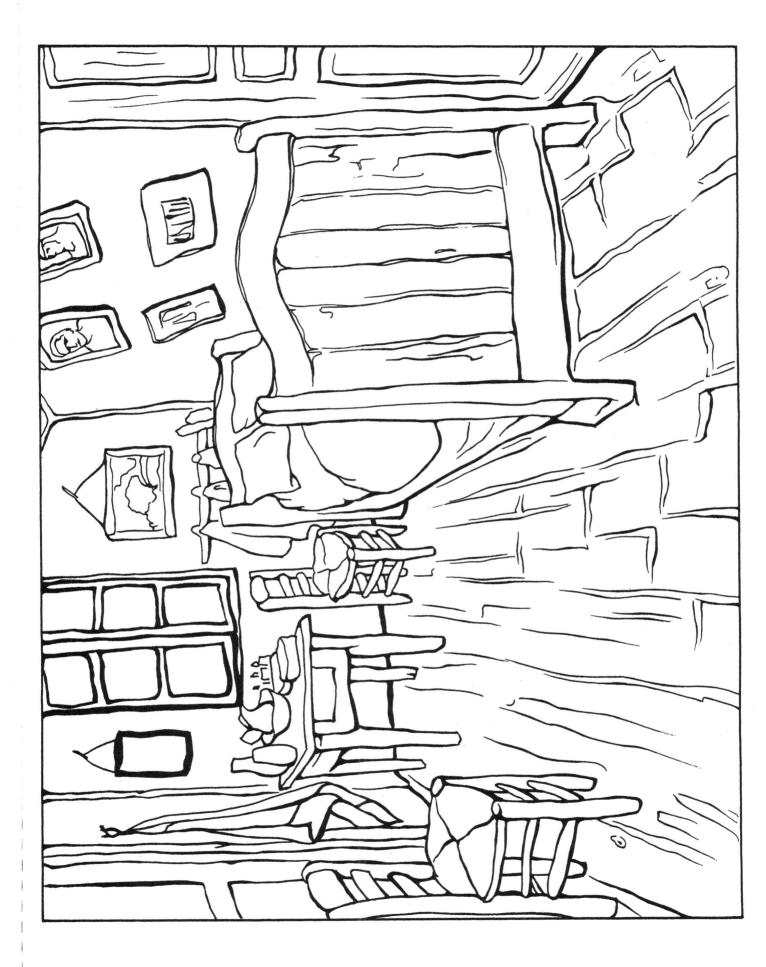

Plate 6
Van Gogh's Bedroom, 1888
Oil on canvas. 28¼ x 35½ in.

This painting depicts Van Gogh's bedroom at Place Lamartine in Arles, known as his Yellow House. There are three authentic versions of this painting, as described by Van Gogh's letters. The way to tell them apart is by the pictures on the painting's wall to the right. You can see the first in Amsterdam's Van Gogh Museum, the second is located at the Art Institute of Chicago, and the third is in Paris's Musée d'Orsay.

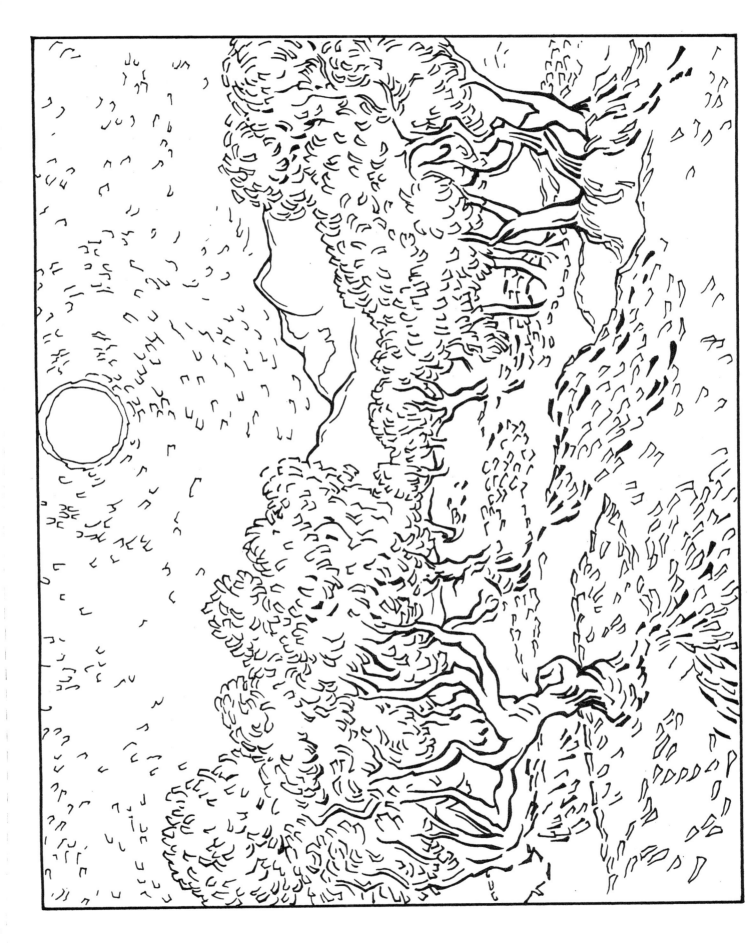

7

Plate 7
Olive Trees, 1889
Oil on canvas. 28¼ x 35½ in.

During his stay at the asylum of Saint-Paul-de-Mausole, van Gogh was often confined to the hospital grounds. He took the few opportunities he had to venture beyond the asylum's walls to create numerous paintings of the olive trees that lay just past its gates.

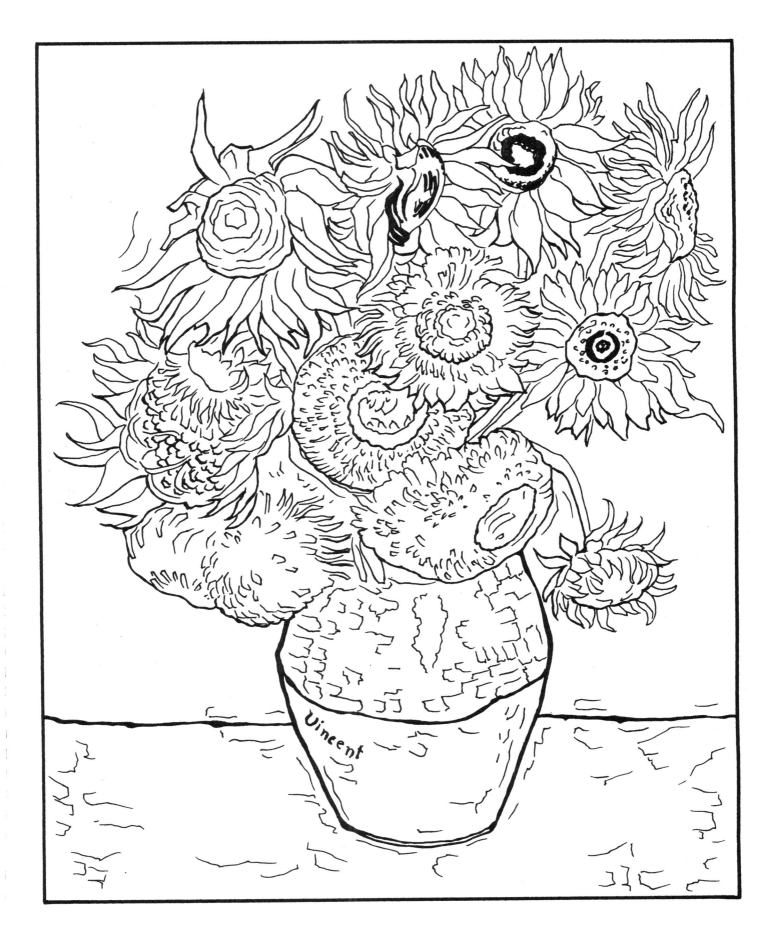

Plate 8
Still Life: Vase with Twelve Sunflowers, 1888
Oil on canvas. 28⅝ x 36 in.

Van Gogh began painting his second sunflowers series, of which this painting is a part, during the summer of 1888, in anticipation of Paul Gauguin's arrival at his home in Arles. Though he planned on creating twelve such paintings, he was only able to complete four before the autumn brought an end to the sunflower season.

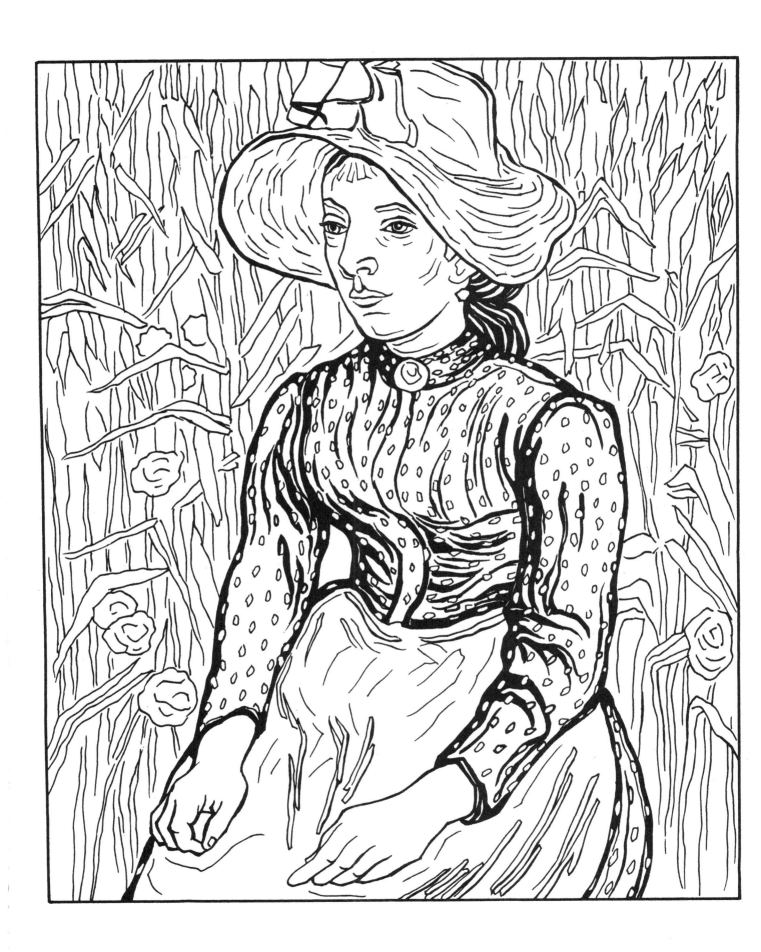

Plate 9
Young Peasant Woman with Straw Hat
Sitting in the Wheat, 1890
Oil on canvas. 36½ x 28¾ in.

It is believed that this painting was completed at Auvers-sur-Oise during the last few months of van Gogh's life, and that the subject is the same woman as in his other painting from this period, *Girl in White*.

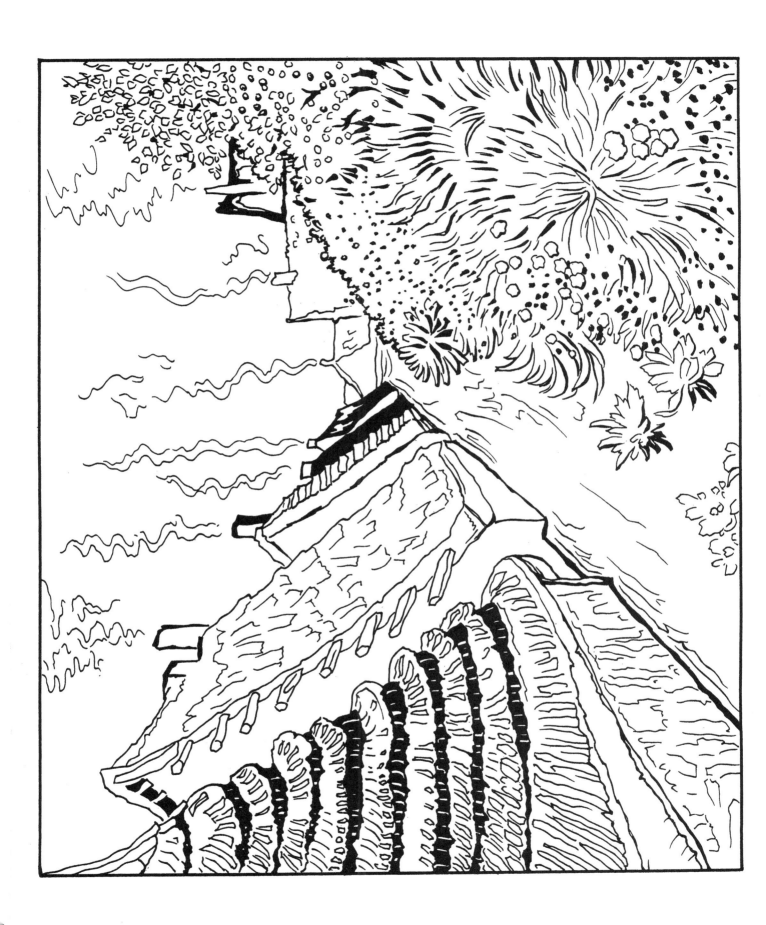

Plate 10
Street in Saintes-Maries, 1888
Oil on canvas. 29 x 36½ in.

The subject of this painting are the thatched roofs and smoking chimneys of Saintes-Maries de la Mer, a small fishing village on the Mediterranean where van Gogh traveled during the summer of 1888.

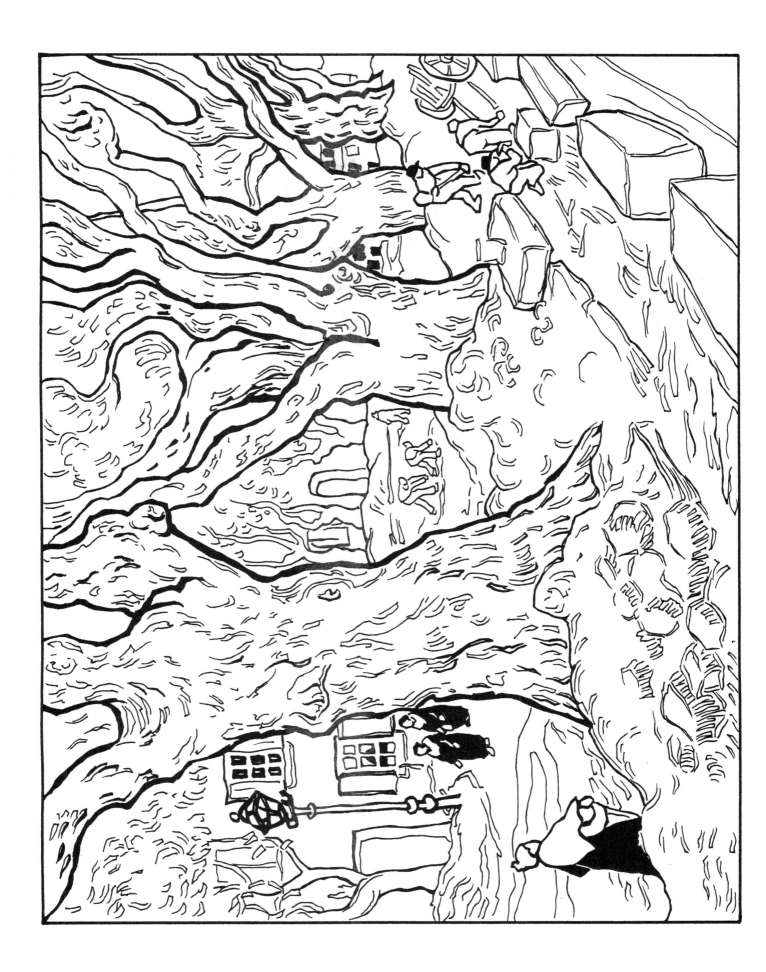

Plate 11
The Road Menders, **1889**
Oil on canvas. 29 x 36½ in.

This painting depicts the Cours de l'Est, a bustling street in Saint-Rémy, during the repaving that took place in the fall and 1889. In a letter to his brother Theo, van Gogh said this of *The Road Menders*: "The last study I have done is a view of the village, where they were at work—under some enormous plane trees—repairing the pavements. So there are heaps of sand, stones and gigantic trunks—the leaves yellowing and here and there you get a glimpse of a house front and small figures."

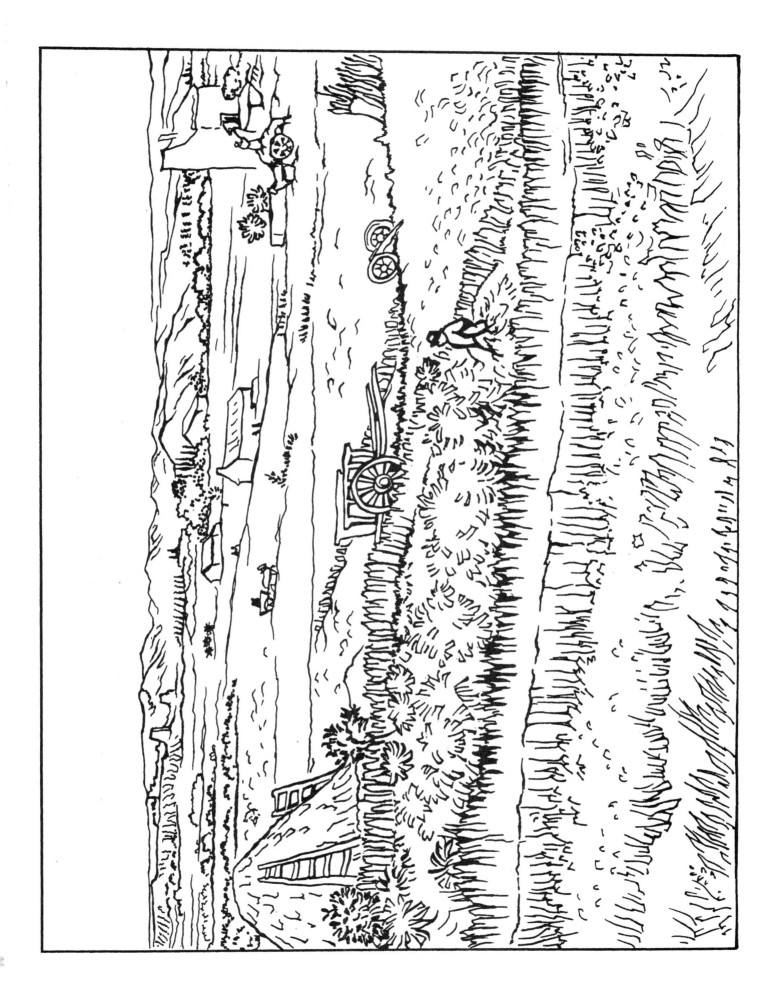

Plate 12
*Harvest at La Crau, with Montmajour
in the Background*, 1888
Oil on canvas. 28¾ x 36¼ in.

The subject of this painting is the rural landscape of fields that sits between Montmajour and Arles. Van Gogh created multiple works of this landscape while traveling through Provence in the summer of 1888, during what is believed to be one of the happiest times in his otherwise troubled life.

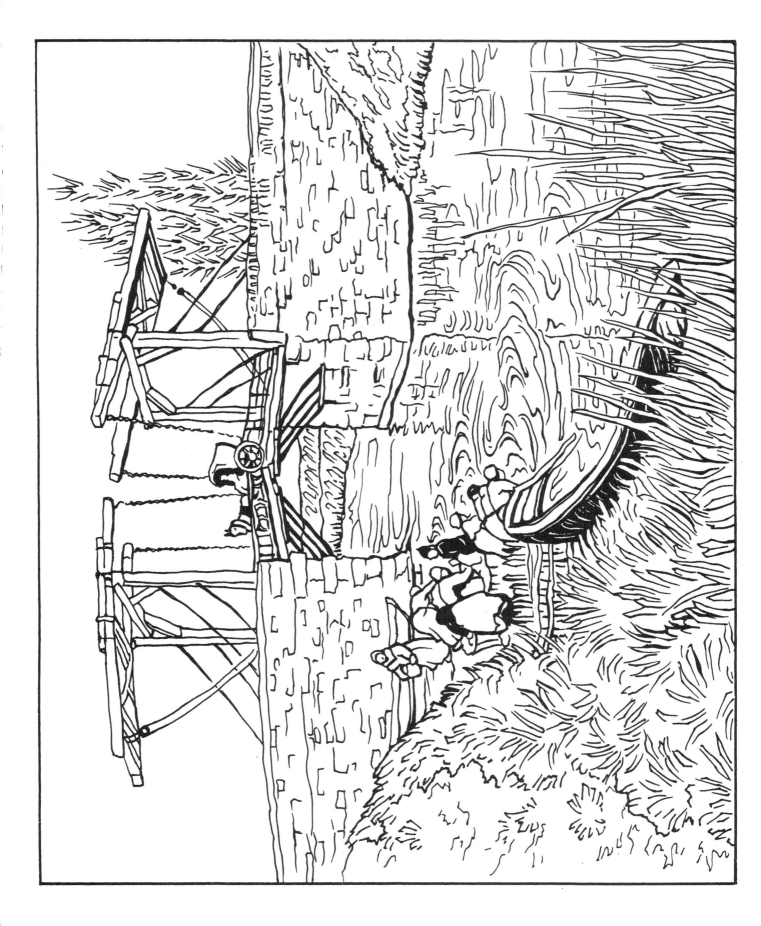

Plate 13
*The Langlois Bridge at Arles with
Women Washing*, 1888
Oil on canvas. 21¼ x 25½ in.

Van Gogh used the Langlois Bridge at Arles as the subject of multiple works, including four oil paintings, one watercolor, and four drawings. The composition and use of color in these works was heavily influenced by the artist's love of Japanese printmaking, and its representation of people working in harmony with nature.

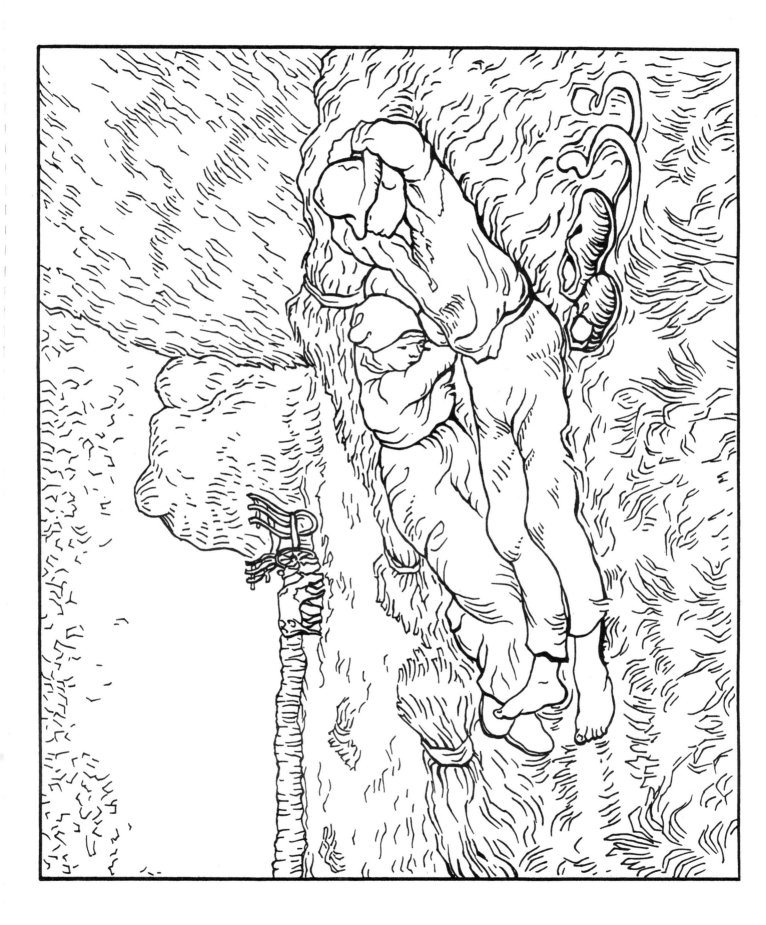

Plate 14
Noon Rest (After Millet), 1890
Oil on canvas. 28¾ x 35¾ in.

This painting is one of more than 20 copies that van Gogh completed from works by Jean-François Millet. It depicts a man and woman taking a mid-day siesta from their work on a farm. While the composition of both works is similar, van Gogh's version is notable for its bold outlines and vibrant use of color.

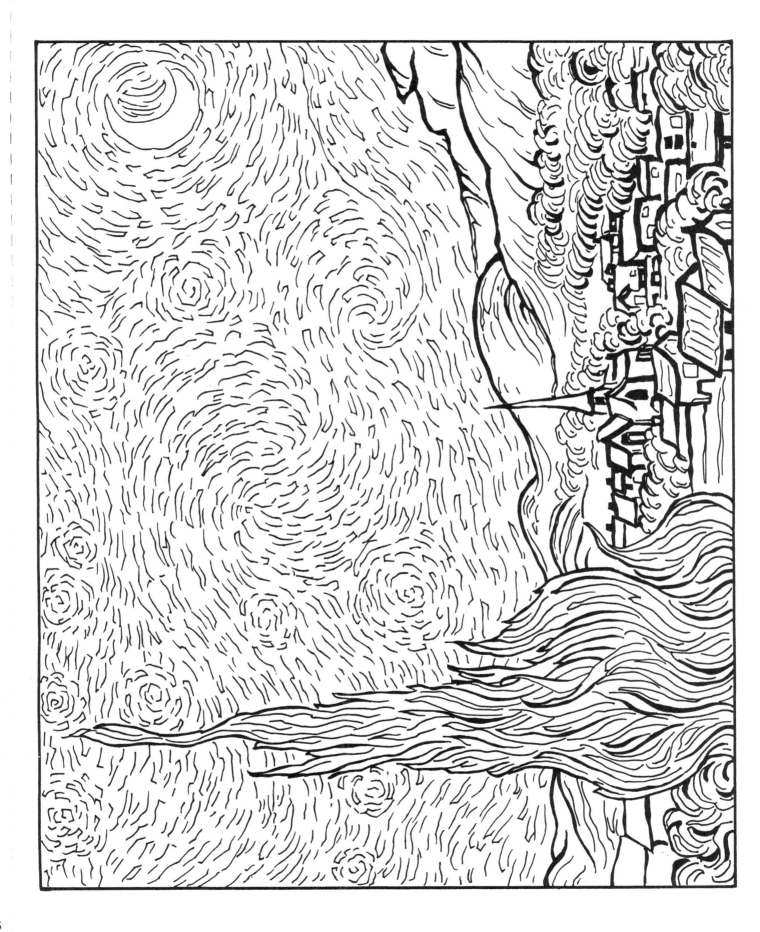

Plate 15
Starry Night, 1889
Oil on canvas. 29 x 36¼ in.

Van Gogh created *Starry Night* while staying in an asylum in Saint-Rémy-de-Provence, France. He painted if from memory and not outdoors as was his usual preference. In the front of this painting, on the left, is a flamelike cypress tree that bisects a quiet village. Swirling waves of energy seem to burst from the canvas. Starry Night has become one of the most well-known images in modern culture and has been the subject of poetry, fiction, and even a popular song by Don McLean. Van Gogh was fascinated with night and wrote to his brother Theo: "It often seems to me that the night is much more alive and richly colored than the day... the problem of painting night scenes and effects on the spot and actually by night interests me enormously."

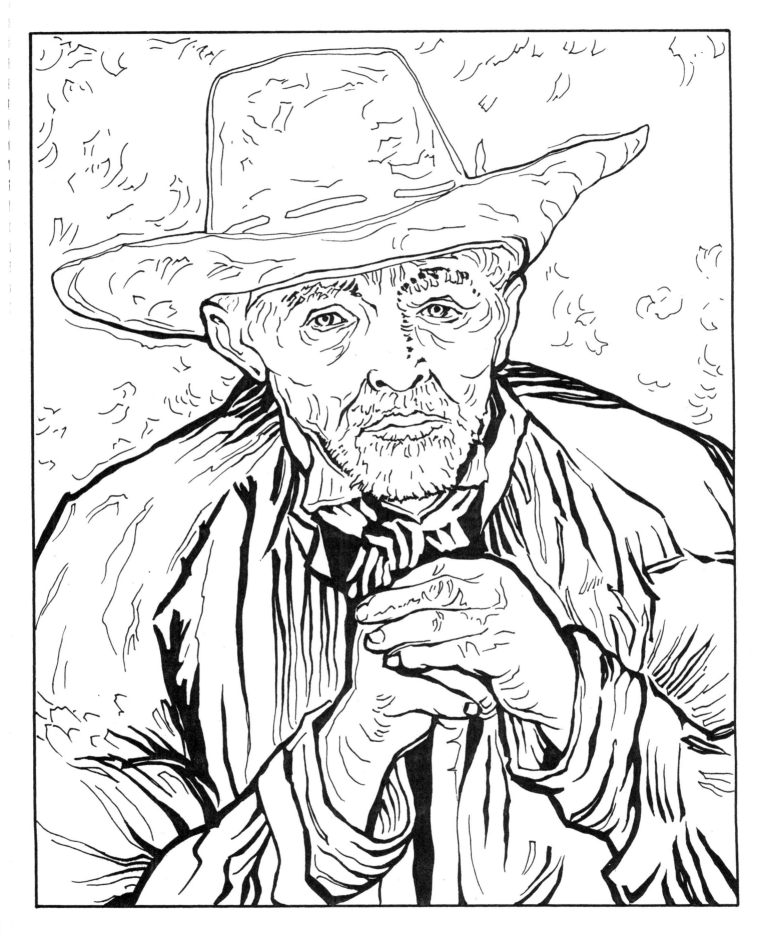

Plate 16
Portrait of Patience Escalier, 1888
Oil on canvas. 25¼ x 21¼ in.

The subject of this portrait is Patience Escalier, a gardener and former goatherd that van Gogh met while living in Arles. It is one of two portraits that he completed of the man.

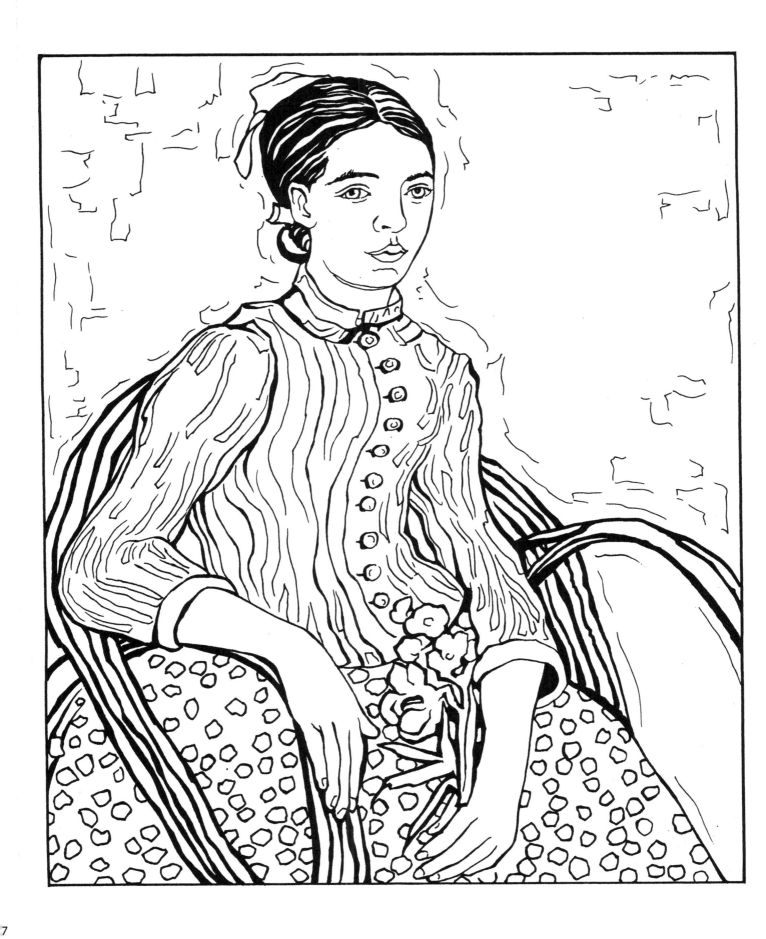

Plate 17
La Mousmé, Seated in a Cane Chair, 1888
Oil on canvas. 29 x 23¾ in.

The subject of *La Mousmé* is a young Japanese girl, in-spired by a character from Pierre Loti's novel, *Madame Chrysanthème*. Van Gogh wrote of this painting in a letter to his brother Theo, saying, "It took me a whole week...but I had to reserve my mental energy to do the mousmé well. A mousmé is a Japanese girl—Provençal in this case—twelve to fourteen years old."

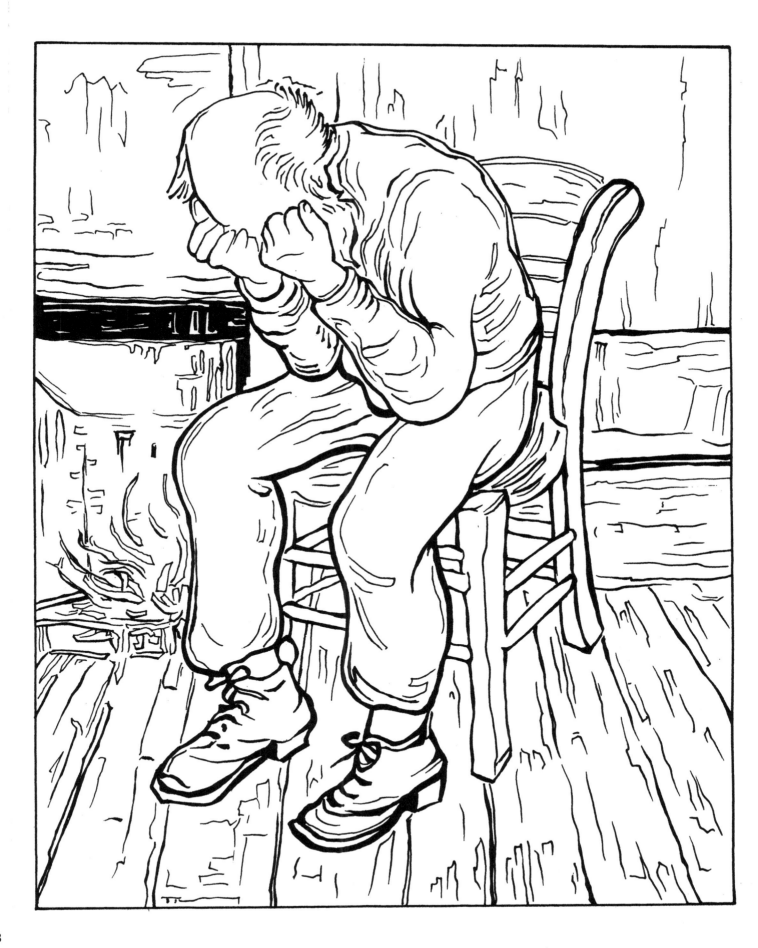

Plate 18
Old Man in Sorrow (On the Threshold of Eternity), 1890
Oil on canvas. 31¾ x 25½ in.

This painting was completed during van Gogh's stay at the asylum in Saint-Rémy de Provence, only a few months before his suicide. Based on a lithograph van Gogh created in 1882, it depicts a pensioner and war veteran van Gogh observed at an almshouse in The Hague.

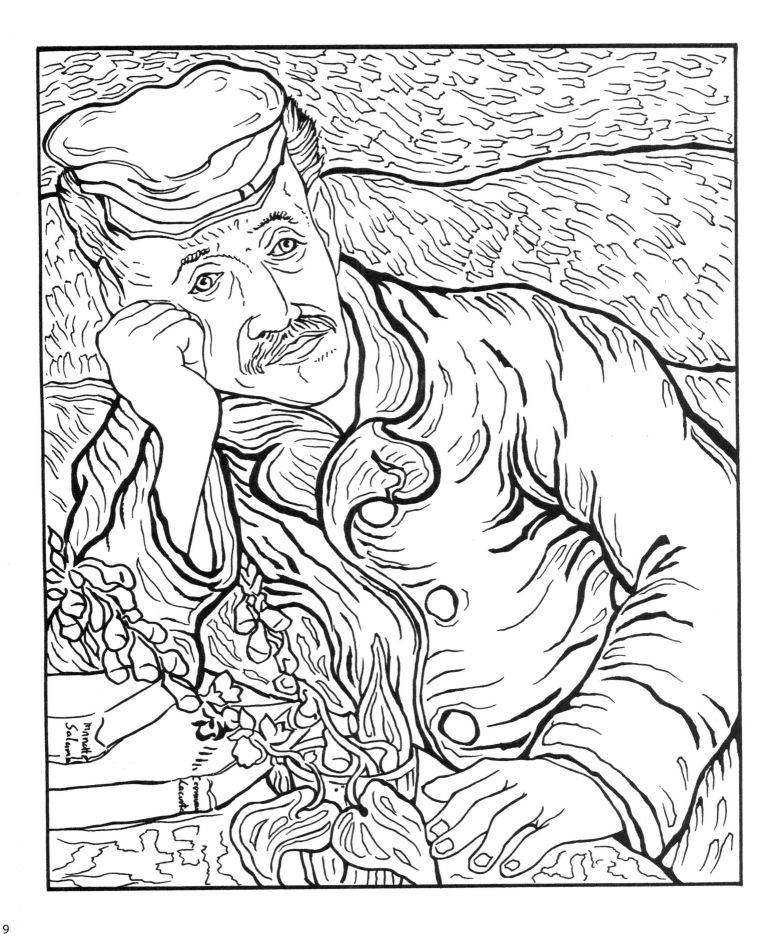

Plate 19
Portrait of Doctor Gachet, **1890**
Oil on canvas. 26¼ x 22 in.

The subject of this portrait is Doctor Paul Gachet, the French physician who took care of van Gogh in Auvers-sur-Oise during the last weeks of his life. Van Gogh wrote the following about this painting in a letter to his brother Theo: "I've done the portrait of M. Gachet with a melancholy expression, which might well seem like a grimace to those who see it...Sad but gentle, yet clear and intelligent, that is how many portraits ought to be done...There are modern heads that may be looked at for a long time, and that may perhaps be looked back on with longing a hundred years later."

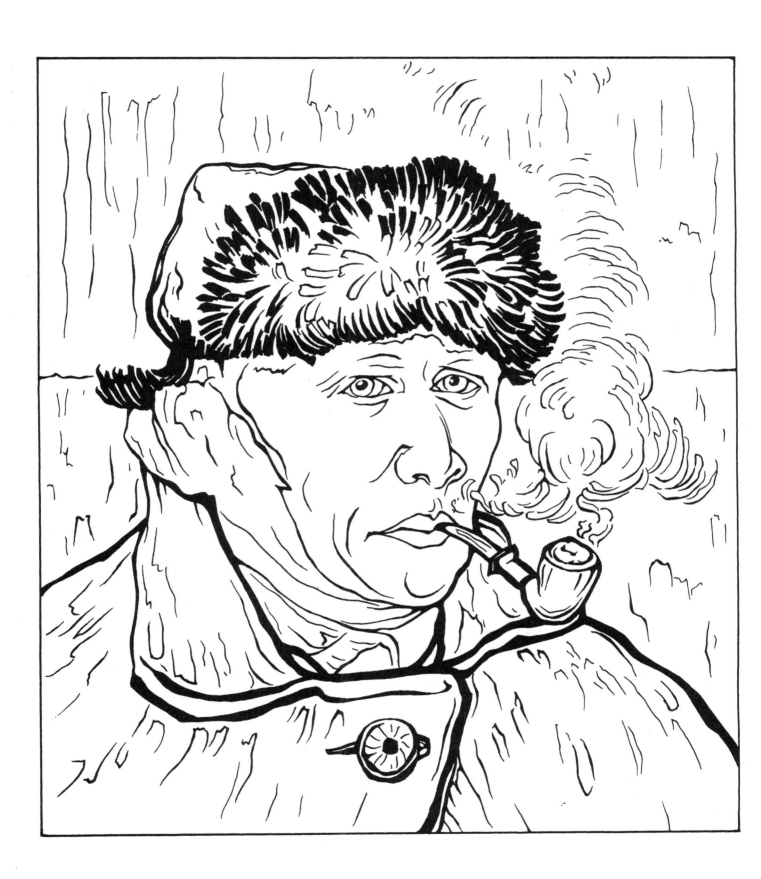

Plate 20
Self-Portrait with Bandaged Ear and Pipe, 1889
Oil on canvas. 17¾ x 20 in.

This self-portrait, one of many van Gogh completed during his life, was painted after the infamous incident in which the artist chased Paul Gauguin with a knife through the streets of Arles, before cutting off part of his own ear and offering it to a prostitute at a local brothel.

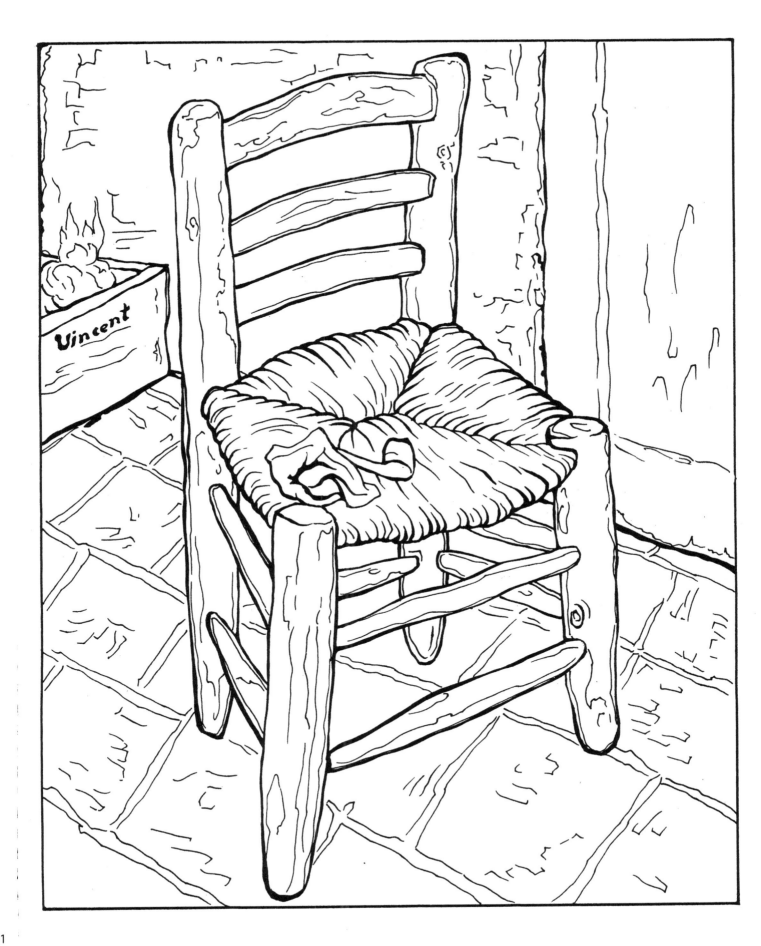

Plate 21
***Vincent's Chair with His Pipe*, 1888**
Oil on canvas. 36½ x 73½ in.

Vincent's Chair with His Pipe is one of two paintings in which van Gogh attempted to portray both himself and his friend Paul Gauguin by painting their respective chairs. Often displayed alongside its counterpart, this "self-portrait" uses rustic elements like the tobacco pouch and simple rush seat to contrast itself from the more elegant items and upholstery in *Gauguin's Chair*.

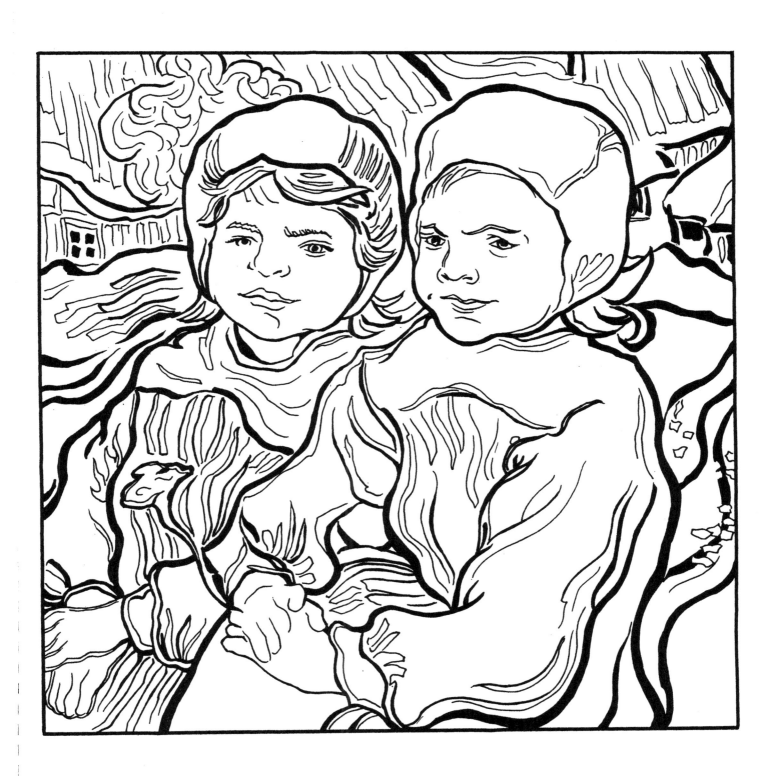

Plate 22
Two Little Girls, 1890
Oil on canvas. 20 x 20 in.

Van Gogh completed *Two Little Girls* during the last months of his life, while living in Auvers-sur-Oise under the care of Dr. Paul Gachet. It is one of two portraits he painted of these subjects, and currently resides at the Musée d'Orsay in Paris.

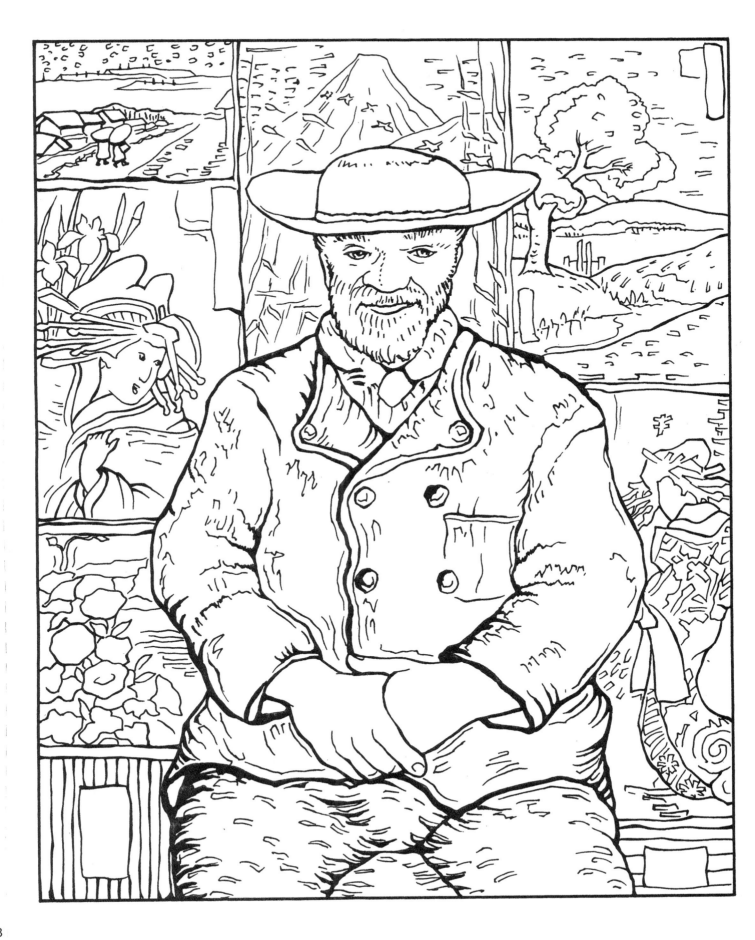

Plate 23
Portrait of Père Tanguy, 1887
Oil on canvas. 36¼ x 29½ in.

This work is one of three portraits that van Gogh painted of Julien Tanguy, a Parisian art dealer who was one of the first to offer van Gogh's paintings for sale. The background of this painting is made up of van Gogh's Japanese prints, which Tanguy had for sale at his shop.

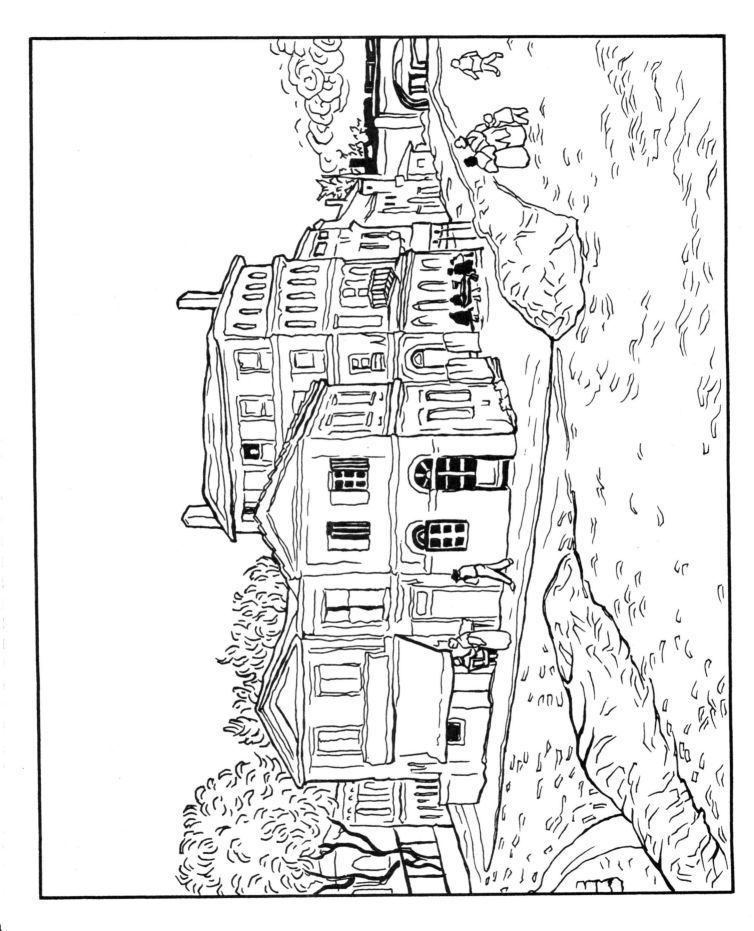

Plate 24
Vincent's House in Arles (**The Yellow House**), **1888**
Oil on canvas. 28¼ x 36 in.

The subject of this painting is the house at 2 Place Lamartine in Arles, where van Gogh lived from May, 1888 to May, 1889. The second-floor room on the corner, shown with both shutters open, is the guest room where Paul Gauguin stayed during the fall of 1888; the room beside it, shown with one shutter closed, was van Gogh's bedroom.

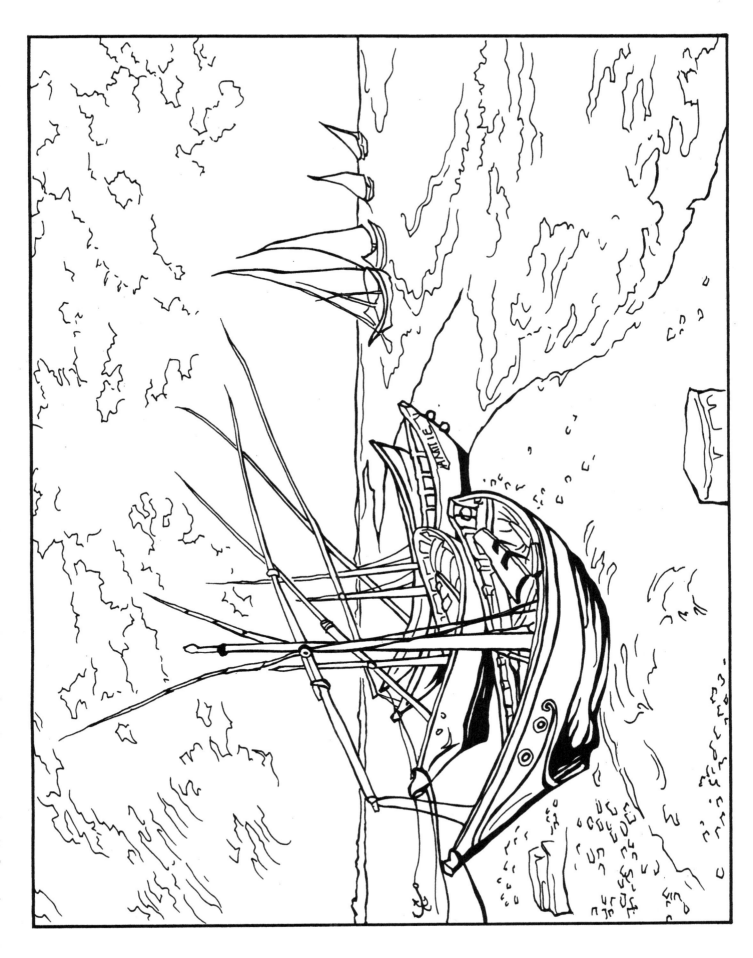

Plate 25
Fishing Boats on the Beach at Saintes-Maries, 1888
Oil on canvas. 25½ x 32 in.

This work is one of three paintings that van Gogh completed in Saintes-Maries de la Mer, a small fishing village on the Mediterranean where van Gogh traveled during the summer of 1888. In a letter to his brother Theo, van Gogh described the painting this way: "I made the drawing of the boats when I left very early in the morning, and I am now working on a painting based on it, a size 30 canvas with more sea and sky on the right. It was before the boats hastened out; I had watched them every morning, but as they leave very early I didn't have time to paint them."

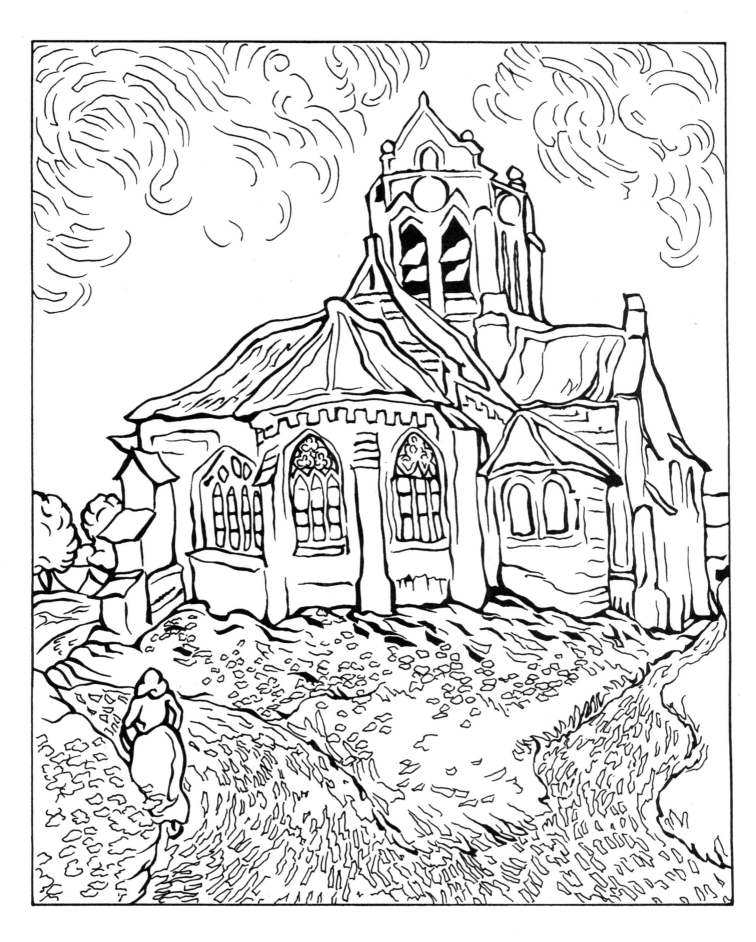

Plate 26
The Church at Auvers, 1890
Oil on canvas. 37 x 29 in.

The church depicted in this painting is located on the Place de l'Eglise in Auvers-sur-Oise, where van Gogh lived during the final months of his life. The church reminded van Gogh of his home in Nuenen, Netherlands, as he states in the following excerpt from a letter to his brother Theo: "I have a larger picture of the village church—an effect in which the building appears to be violet-hued against a sky of simple deep blue color, pure cobalt; the stained-glass windows appear as ultramarine blotches, the roof is violet and partly orange...And once again it is nearly the same thing as the studies I did in Nuenen of the old tower and the cemetery, only it is probably that now the color is more expressive, more sumptuous."

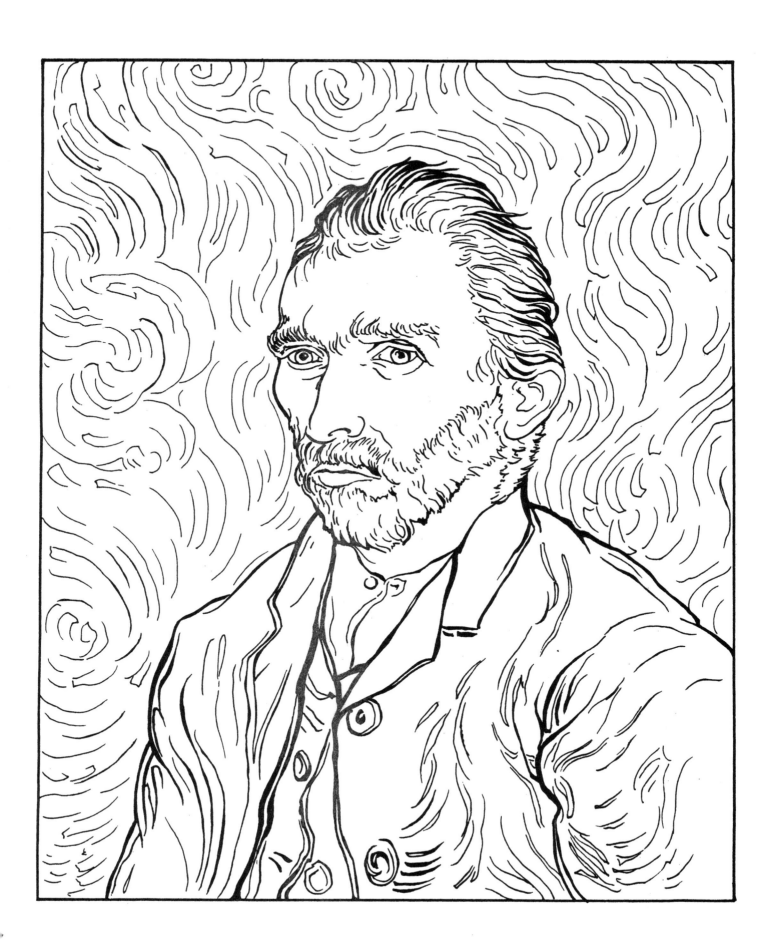

Plate 27
Self-Portrait, **1889**
Oil on canvas. 25½ x 21½ in.

Van Gogh painted over 40 self-portraits at regular inter-
vals throughout his life. As he later wrote in a letter to
his brother: "If I succeed in painting the colors of my own
face, which is not without its own difficulties, then I should
be able to paint those of other men and women." Van Gogh
completed this painting, arguably his most famous self-
portrait, shortly after leaving the asylum in Saint-Rémy-
de-Provence. It is particularly notable for the intensity of
emotion it expresses, both through its depiction the art-
ist's tormented visage, as well as the churning arabesques
in the background.

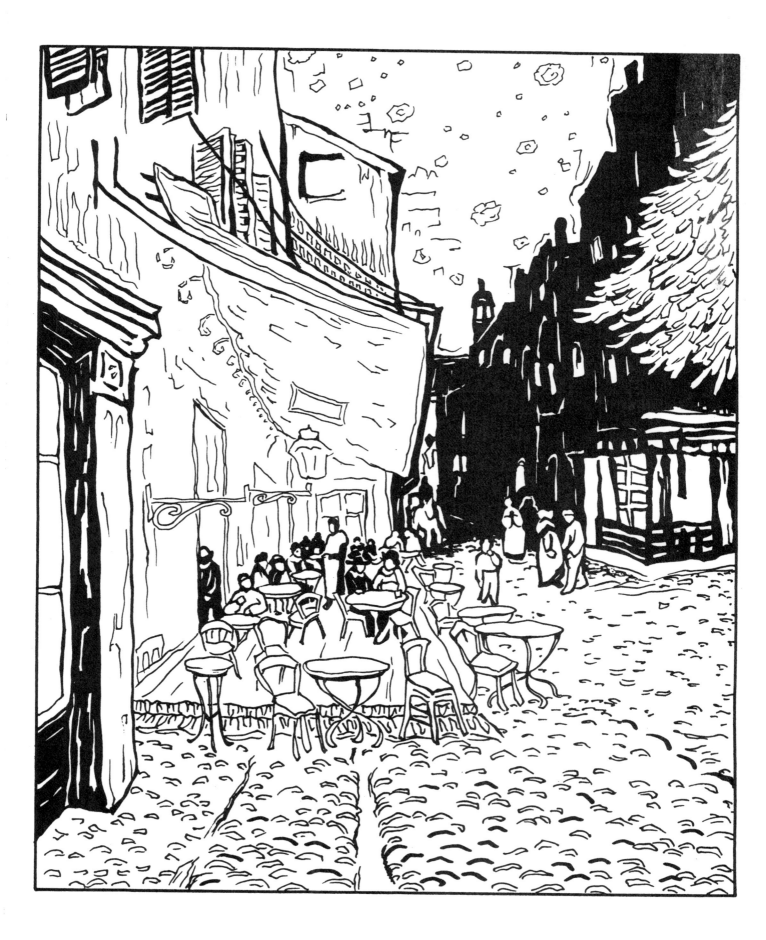

Plate 28
Café Terrace at Night, **1888**
Oil on canvas. 31¾ x 25¾ in.

When this painting was exhibited for the first time, it was titled *Coffeehouse, in the Evening*. This is the first painting in which van Gogh used a starry background. His most famous work, *Starry Night*, was completed one year later, in 1889. After finishing this painting, Van Gogh wrote a letter to his sister that expressed his feelings about it: "Here you have a night painting without black, with nothing but beautiful blue and violet and green...It amuses me enormously to paint the night right on the spot. Normally, one draws and paints the painting during the daytime...But I like to paint the thing immediately."

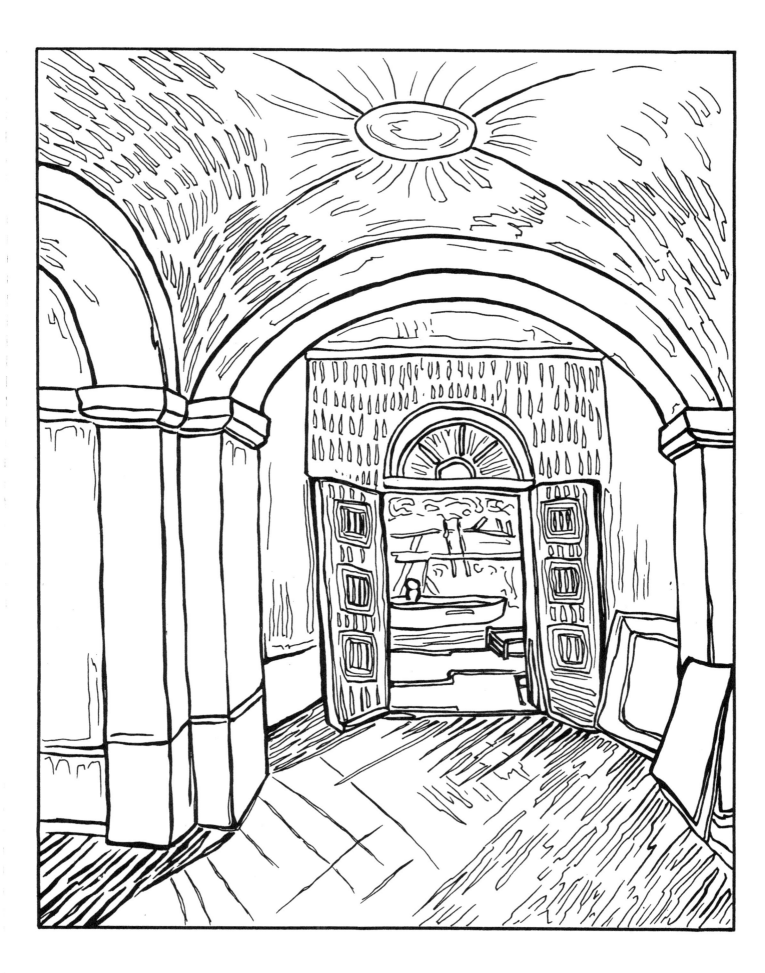

Plate 29
The Entrance to the Hall of Saint-Paul Hospital, 1889
Gouache. 24¼ x 18½ in.

The subject of this painting is the entrance hall at the asylum of Saint-Paul-de-Mausole in Saint-Rémy, Provence, where van Gogh voluntarily admitted himself in 1889. In addition to the two paintings he made of the asylum's corridors, van Gogh also completed numerous works during his twelve-month stay at Saint-Rémy, including *Olive Trees*, *Still Life with Irises*, and *Starry Night*.

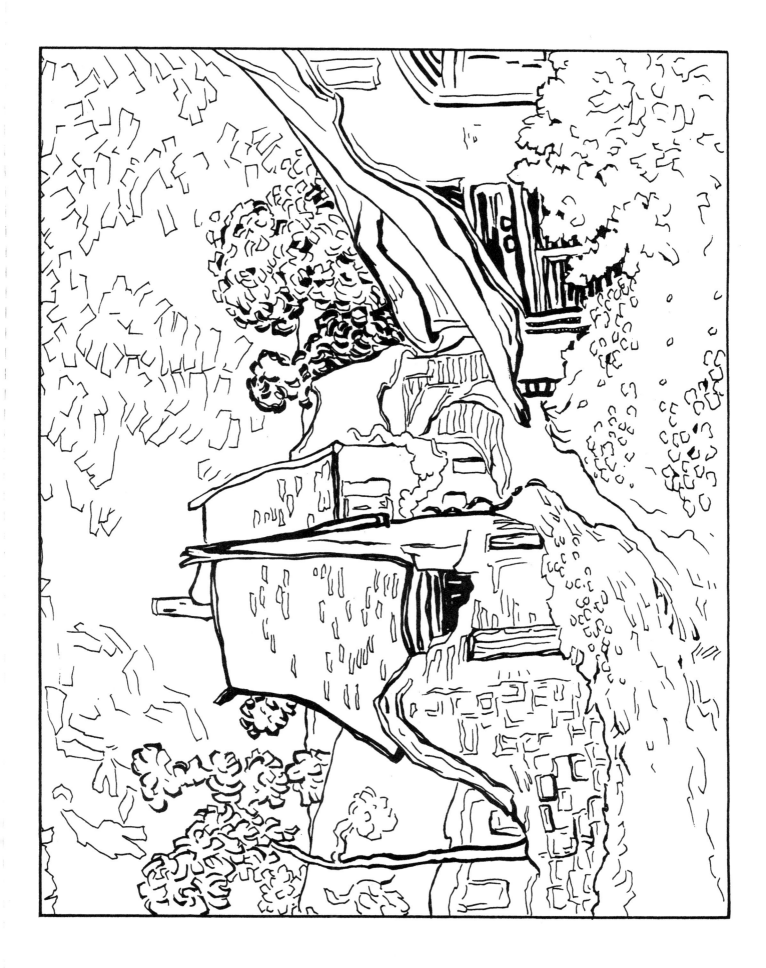

Plate 30
Village Street in Auvers, **1890**
Oil on canvas. 28¾ x 36¼ in.

The subject of this painting is a quiet village road in Auvers-sur-Oise, where van Gogh spent the last two months of his life. During this time, van Gogh completed over eighty unique works—an average of more than one per day.